2020

...The Year We Were All

Cancelled!

Stella

2020 – The Year We Were All Cancelled !
By Stella
2020

Publisher: Radical Cartoons
Unit 355 Bristol Business Centre,
179 Whiteladies Road,
Clifton, Bristol BS8 2AG
Email: radicalcartoons@gmail.com

Dedicated to:

All Journalists killed in the course of their work. As this book went to press, 17 journalists were confirmed killed in 2020, (Source: the Committee to Protect Journalists cpj.org)

Cartoons © "Stella"

ISBN: 978-1-5272-7143-2

Red Snowflake Reviews for 2020 -The Year We Were All Cancelled!

FRANK FUREDI (ANN FUREDI'S Husband)
Emeritus Professor of Sociology at the University of Kent
www.frankfuredi.com

These cartoons are brave, brilliant and really funny.

4 Red Snowflakes!

JENNIFER BILEK Artist, environmental activist, cutting-edge feminist www.the11thhourblog.com

If our cartoonists go down with our journalists, both under threat, we will have no means to fight. Stella's work goes where people are terrified to tread, providing levity while making us laugh out loud. I raise my glass!

1 Million Red Snowflakes!

ROB JESSEL Co-founder of FAIRCOP
www.faircop.org.uk

In a year when everyone's been cancelled, Stella is one of the few to stand up and say, "the Emperor is naked".

5 Red Snowflakes!

JO BARTOSCH Writer, feminist campaigner and 'recovering Marxist'! Director of CLICK OFF www.clickoff.org

Brave and brilliant, this cartoon collection is satire at its finest; no-one is spared from Perrett's insightful take on politics and power. Recommended antidote to the woke world of 'isms' and perpetual offence.

Off The Scale!

I have used the Red Snowflake as both a rating system for possible offensiveness, and also as a warning to real-life snowflakes who might have inadvertently received this book for Christmas!

INTRODUCTION

THOSE OF US LUCKY ENOUGH NOT TO BE LIVING IN SLAVERY OR A WAR ZONE will look back on **2020** as possibly the **strangest year of our lives.**

Who knew, on January 1st, when we finally put four years of Brexit controversy to bed; that the deep breath we all took was not the end of a trauma but the prelude to a year the like of which none of us could have foreseen...

THE YEAR WE WERE ALL CANCELLED!

Like many other people (mainly women) in the arts, comedy, academia, and in ordinary businesses; I was cancelled in 2020 for exercising my right to free speech.

It was all the stranger, because I was a political cartoonist for a national daily newspaper, whose job it was to make legitimate and pertinent points about issues in the news! But this did not protect me from the mobs who have taken over the public square and are ready to pounce on any perceived transgression against their own pet projects or belief systems.

You may have seen some of my cartoons in the *Morning Star* between 2015 - February this year;on spinster.xyz, on the news/comment site uncancelled.co.uk. or on my own websites (see right).

So here is my retrospective of 2020 -
The Year We Were All Cancelled!
The STRANGEST year of our lives...

STELLA
Political Cartoonist
and
Book Illustrator

based in Bristol, England

www.spanglefish.com/
stellaillustrator
www.spanglefish.com/
thebigpinkbook
www.spanglefish.com/
TheSalineDrips

INDEX

NOTE: on some cartoons you will see a side panel with my own analysis of its offensiveness rating, to facilitate Friendly Family Discussion at the Dinner Table.

There are 2 sub-sections with PROMINENT "Red Snowflake Alerts", so that those delicate readers who wish to avoid anything remotely 'gender-critical', can utilise their 'coping mechanisms', and carefully skip the 'triggering' pages!

RED SNOWFLAKE RATING

RED SNOWFLAKE ALERT!

New Year to Start of Lockdown -

the *STRANGEST* year of our lives!

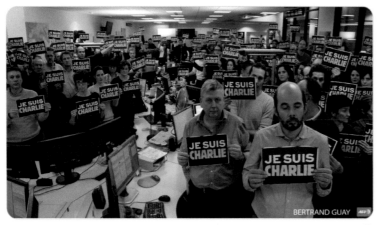

RIP Charlie Hebdo cartoonists

**Massacred in their office, 5 years ago today
for exercising their legal right to free expression**
*Editor: Stephane ("Charb") Charbonnier, and
Cartoonists: Jean ("Cabu") Cabut, Georges ("Wolin") Wolinski, Bernard
("Tignous") Verlhac, Phillipe ("Honore") Honore + 6 others*
CANCELLED BUT NOT FORGOTTEN

2

The "MARKLES" CANCEL THEMSELVES from the Royal Family!

This was my last cartoon published in the Morning Star.

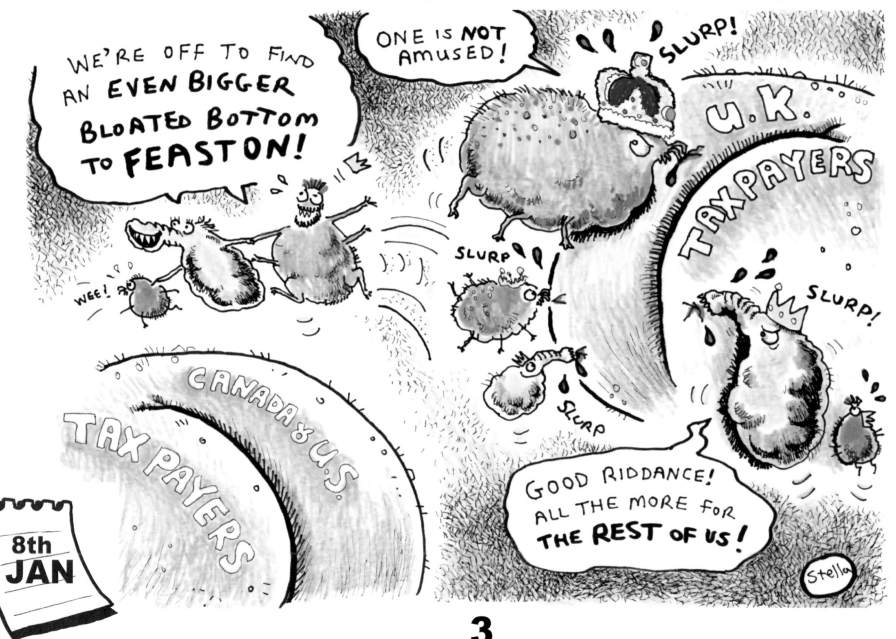

3

The Official Brexit Day party in Parliament Square...

BIG BEN REAL CHIMES -
NOT ALLOWED!
FIREWORKS –
NOT ALLLOWED!
LIVE MUSIC -
NOT ALLOWED!
THE PM's speech to the Nation -
NOT BROADCAST by the BBC!!
(The 'Public Service' broadcaster, for which all Brits who own a television have to pay a tax)!

So that got the YEAR WE WERE ALL CANCELLED OFF TO AN
EXCELLENT START!

Onwards and upwards!

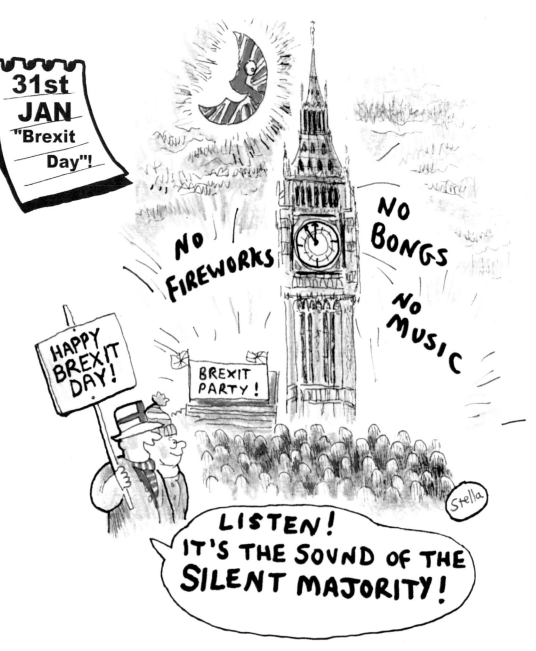

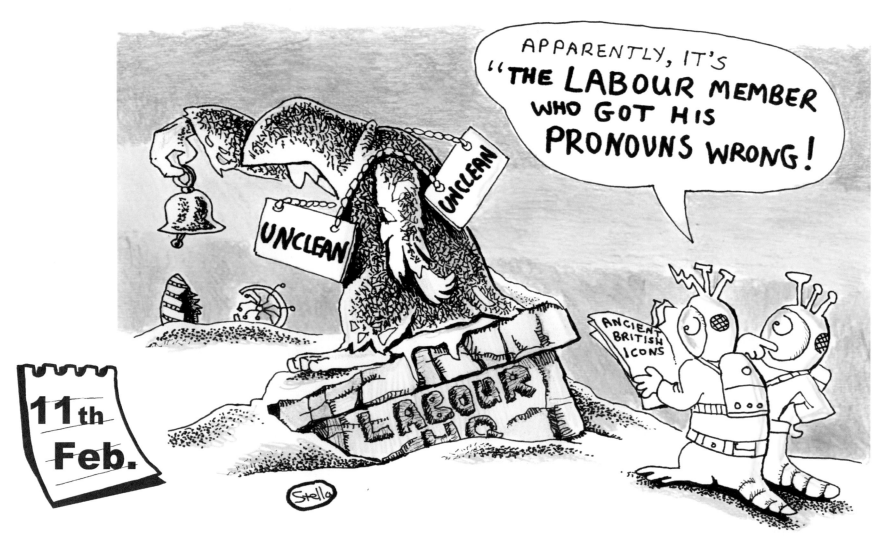

Demonstrating that they were perfectly capable of taking the 2019 General Election defeat lying face down in a pile of their own manure, the LABOUR PARTY Leadership candidates signed a "Trans PLEDGE", threatening to expel any party member who mispronouned anyone! Cue much mirth on social media. This brought to the general public's attention, (for many people, like me, for the first time) the issue of "preferred pronouns".

Haters of Free Speech and Free Expression
do not care what an artist's own reason or motivation is.
They use a base appeal to people's fear of being labelled bigoted.
The main "Isms" used to cancel artists are:
Racism
Anti-Semitism
Anti-Islamism
Anti-Trans-ism
Sometime "phobia" is added (Islam-a -phobia, Trans-phobia) to imply
that you are not only AGAINST the thing but also AFRAID of it.
Hands up, I believe I am the only *female* political cartoonist who has
been cancelled by a national newspaper in the UK.
But I am in good company.
Let's meet some of them!

WELCOME TO THE "CANCELLED CLUB"!

Mail Online

What it feels like to be CANCELLED: It's the mob's weapon of choice - trying to take away their victim's livelihood - it's even happened to the cartoonist for the Communist Morning Star

By **NICK CRAVEN** 12 July 2020

The left-wing cartoonist

Civil servant Stella Perrett had supplied edgy cartoons for the Communist Morning Star newspaper for years until February 2020 when she found that being on the Left is no protection against cancellation.

A lifelong feminist, she had strong views about 'self-identifying' trans women being allowed into female-only spaces such as domestic violence refuges and toilets.

She wanted to highlight the dangers of the 'pledge' by three women candidates in the Labour leadership contest backing self-identification to be enshrined in law, so she drew a cartoon of a crocodile sliding into a bathing pool and telling several worried newts: 'Don't worry your pretty little heads! I'm transitioning as a newt!'

Ms Perrett, 60, also included a note for publication explaining that when she was a girl, she was convinced that she was really a boy, but realises now it was just a phase.

According to some insiders, there was even talk of pulling the plug on the ailing newspaper, so within days came a much longer 600-word apology to its readers and a promise to the unions behind the scenes not to use Ms Perrett again.

A phone call from the police followed after a 'hate crime' was reported and recorded, but the police confirmed yesterday that no further action was taken.

Then, someone in the PCS civil servants' union, for which Ms Perrett was an unpaid official, started baying for her to be kicked out of her post. She was summoned to a disciplinary hearing.

'I was close to retirement, and while I loved my union work, I just decided to stand down,' Ms Perrett told The Mail on Sunday.

A lifelong feminist, she had strong views about 'self-identifying' trans women being allowed into female-only spaces such as domestic violence refuges and toilets

'The whole thing was tremendously stressful. I felt very let down by the paper and by the union. They both threw me under the bus.

'Cartoons are supposed to be edgy – even offensive – to provoke debate, but these days some people seem to want to stifle views which are different from their own.' The Morning Star declined to comment.

Numerous media, on and offline, have now told my story and re-printed the cartoon, but because it has been reported to the police as a 'non-crime hate incident', I am not reproducing it here.

It is easy to just google my name and find it, and also the abuse and libel directed at me on social media.

I have provided a list of outlets which published thoughtful analysis of this episode, at the end of this book.

7

"THE CARTOON"

2013

Rupert Murdoch apologises over Gerald Scarfe cartoon

🕐 29 January 2013

pandaemonium

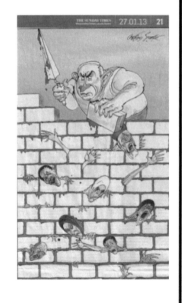

Pandemonium website reprinted the cartoon, published in the Sunday Times, and defended Scarfe, saying: "Scarfe's cartoon is not about Jews, nor even about Israeli actions in general, but specifically about Netenyahu's policies".

However, there was outrage from Jewish organisations world-wide and Rupert Murdoch issued an apology.

The perceived offence was compounded by the fact that the cartoon appeared on Holocaust Memorial Day.

Gerald Scarfe, former Editorial cartoonist for The Sunday Times, also contributed to The New Yorker, and still appears in the London Evening Standard and other newspapers and periodicals.

BuzzFeed News **2018**

Buzzfeed reprinted this tweet about Bell's allegedly "anti-semitic" cartoon, cancelled by The Guardian :

The @Guardian is holding back publication of Steve Bell's latest 'toon.
Mustn't upset Benjamin Netanyahu...

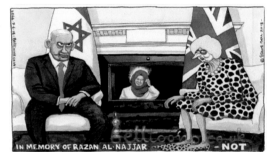

8:48 PM · Jun 6, 2018 ⓘ

Bell emailed the newspaper's staff to complain, explaining that the space in between the two figures, from a photograph of the meeting, which was an actual fireplace, was the most convenient place in the picture to put the figure of Razan al-Najjar, shot and killed by Israeli security forces.

He was amazed that the fact that it was a fireplace should make it anti-Semitic, and said: "That was the last thing on my mind when I drew it. I had no intention of conflating the issues of mass murder of European Jews and Gaza".

Steve Bell, Guardian cartoonist, well known for his long running cartoon strip "If..." his cartoons have been repeatedly controversial.

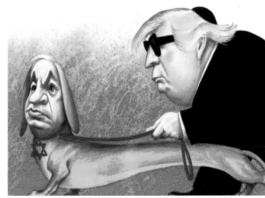

A caricature of Prime Minister Benjamin Netanyahu and US President Donald Trump published in The New York Times international edition on April 25, 2019, which the paper later acknowledged "included anti Semitic tropes." (Courtesy)

The New York Times on Saturday acknowledged publishing a caricature in its international edition that it said "included anti-Semitic tropes" and called its use an "error of judgment." for carrying the cartoon.

The Times of Israel re-printed this cartoon from the NYT, on 27 April 2019.

By 11 May, following world-wide condemnation, the NYT issued an apology, disciplined the Editor responsible, and cancelled cartoon contracts with long standing cartoonists.

By 11 June, they had vowed to stop publishing political cartoons – like, ever – in their international edition.

But not all journalists or newspapers, or free speech campaigners, agreed with them.

On 12 Jun, THE GUARDIAN'S *(and frequently also the Morning Star's)* cartoonist, Martin Rowson, wrote a strong condemnation in the Guardian, of the NYT's decision.

The New York Times political cartoon ban is a sinister and dangerous over-reaction
Martin Rowson

He spoke for all political cartoonists when he said: "In turning a satirical mirror on the news, we are used to facing attack, but this was a pompous and hypocritical decision".

Political cartoonists everywhere have used the image of one politician being led on a lead by another, as their 'poodle'. For what my view is worth, I do not think the original cartoonist thought that this would be seen as anti-Semitic.

Firstpost.

New York Times to stop publishing political cartoons after Benjamin Netanyahu caricature causes anti-Semitism row

The New York Times has announced it will no longer include daily political cartoons in its international edition, weeks after apologising for publishing a caricature of Israeli Prime Minister Benjamin Netanyahu.

Agence France-Presse | June 11, 2019 15:16:52 IST

New York Times, 2019 - Founded in 1851. based in New York City.

Has won 130 Pulitzer Prizes, more than any other newspaper. Not the bastion of free speech it claims to be. In July 2020, BARI WEISS, one of their female opinion writers and editors resigned, citing "bullying by colleagues" and an "illiberal environment".

NIKKEI ASIAN REVIEW

Danish coronavirus flag cartoon sparks outrage in Beijing

Jyllands-Posten newspaper defends decision with prime minister on its side

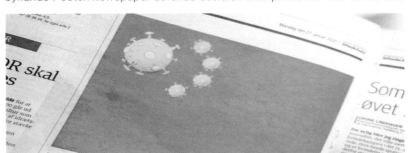

THE LOCAL dk

'We have free speech': Danish PM

In January 2020 Danish paper Jyllands-Posten published this cartoon about the Covid-19 Virus, which clearly stressed its Chinese origins. China created a diplomatic incident, demanding public apologies from the Editor and journalists. However the paper's Editor, and Denmark's Prime Minister Mette Frederickson, defended the artist's freedom of expression saying: "We have a very strong tradition in Denmark, not only for free speech, but also for satirical drawings, and that will continue into the future..."

In 2005 the paper had published a cartoon of the Prophet Mohammed which triggered violence across the Muslim world, and was later re-printed by Charlie Hebdo, leading indirectly to the massacre of that paper's cartoonists and staff in 2015.

Jyllands-Posten

Founded in 1871, based in Aarhus C, Jutland, Denmark. With a history of controversial cartoons and Editorial robustness.

THE "CANCELLED CARTOONISTS CLUB"

The thing I have I common with these other political cartoonists I have featured is, that we all maintain our innocence of the 'anti-isms' and 'x-phobias' you accuse us of.

We are a part of journalism – an important part, since we can speak in our images, to readers who may not share our languages, but can understand the instant message of a cartoon.

We defend our art and our freedom of expression. We are not deliberately creating 'hateful' images, but making legitimate points about important issues in the news, to show different angles, and initialise discussion.

Here is Jordanian cartoonist, EMAD HAJJAJ, speaking on his release from arbitrary detention on 30 August 2020, pending a trial on the charge of 'disturbing relations with a sister country', for his cartoon satirising the UAE-Israel peace deal. By the time you read this, he could be serving two years in prison:

"I did not commit any crime. Political cartoons are an artist's basic right to express his opinions. They are at the heart of democratic discourse".

From his interview with Al Jazeera 30 August 2020

8 th March

My INTERNATIONAL WOMAN'S DAY 2020 CARTOON

combined the Legend of the Warning (or Beckoning) Cat with the Gender Ideology 'pandemic', women being silenced - and the Covid-19 actual pandemic.

The legend is originally Japanese, but has spread throughout East Asia. Every Chinese chip shop in the UK has one of these cats, ceramic or plastic, some with motorised waving arms.

The cat is described as waving, warning, or beckoning, but all it is doing is washing behind its ears. The legend involves a Temple Cat, who variously warns a stranger, or a fugitive, or invites him into the safety of the Temple, to escape either a thunderbolt, or armed Samurai who are pursuing him.

This has percolated to the West in the "Old Wives Tale" that bad weather is coming if the cat washes behind its ears!

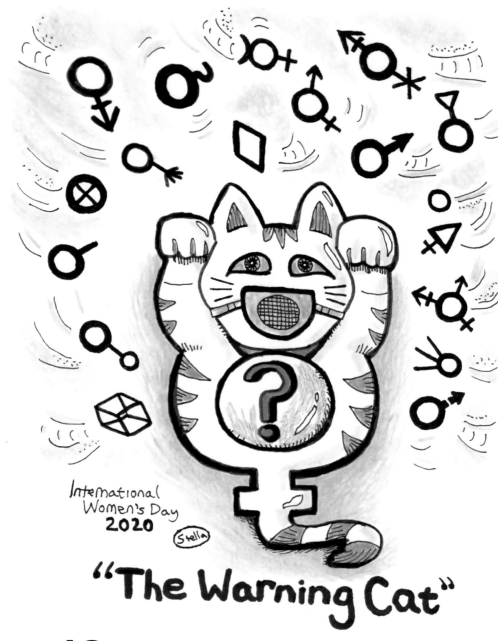

International Women's Day 2020 (Stella)

"The Warning Cat"

12

NORMAL LIFE WAS CANCELLED

as UK entered Lockdown. Brits were CANCELLED FROM:

Pubs and social events;
schools (except for key worker's families);
universities;
from 'unnecessary' travel, except for commuting to work, shopping, or visiting family.
We were allowed one hour a day of outside exercise, in a deployment of power over Her Majesty's Subjects not used even during two World Wars.

But on the plus side, Facial Recognition Software became obsolete!

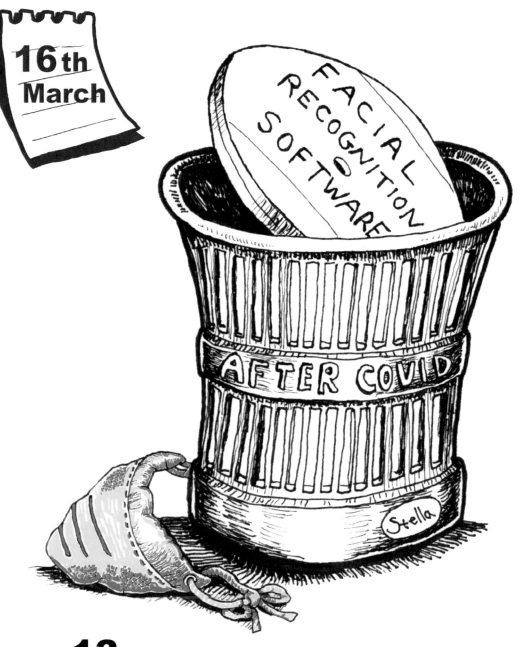

16th March

FACIAL RECOGNITION SOFTWARE

AFTER COVID

Stella

13

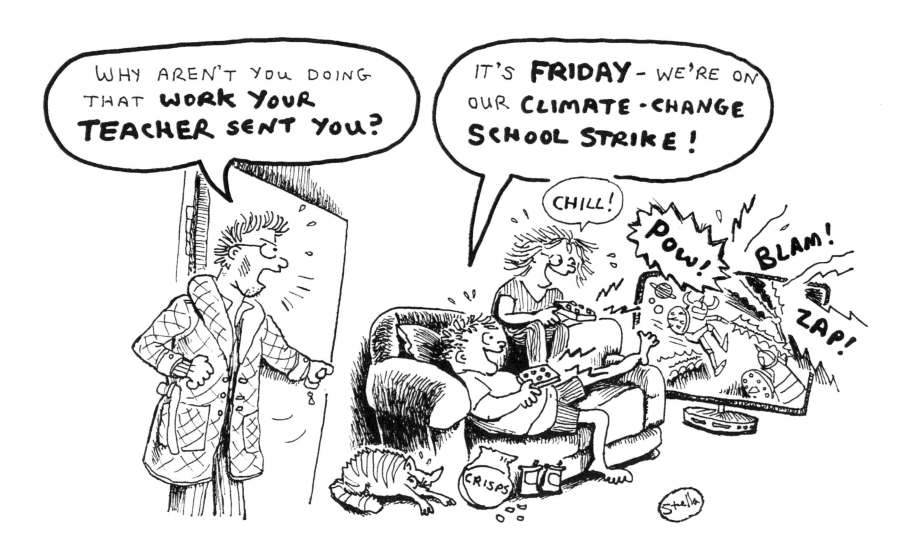

UK LOCKDOWN - SCHOOL CANCELLED!

Millions of 'XR Generation' kids suddenly realised that governments could actually be QUITE USEFUL ATER ALL! I take my hat off to their parents, who were suddenly expected to oversee remote-schooling, alongside their own jobs!

14

For a brief, wonderful moment, we thought the SILVER LINING of the Covid cloud might be no more privileged, white, middle-class, SELFIE FESTS blocking our streets!

WOULD EXTINCTION REBELLION PROTESTS BE CANCELLED?? *

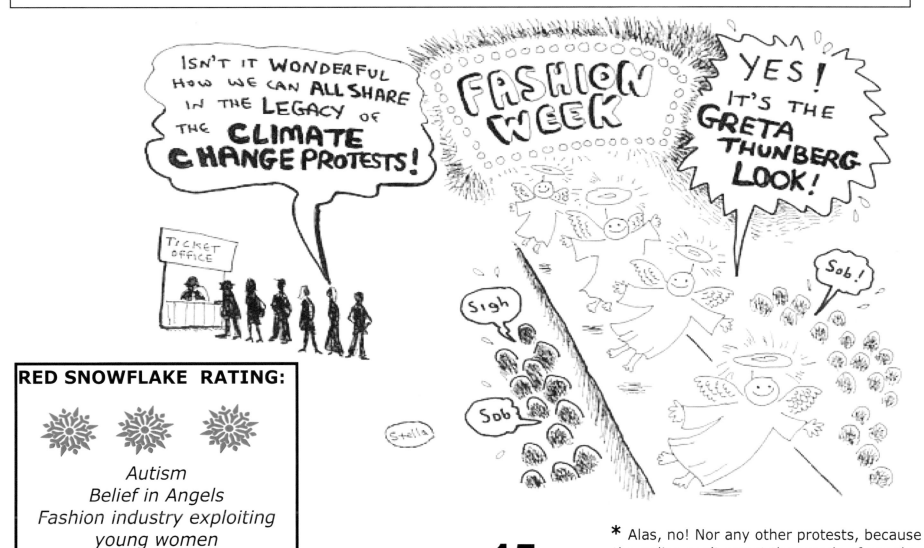

RED SNOWFLAKE RATING:

*Autism
Belief in Angels
Fashion industry exploiting young women*

* Alas, no! Nor any other protests, because the police can't arrest thousands of people.

Our Spring and Summer of COVID 19 to end of UK Lockdown...

er, we thought!

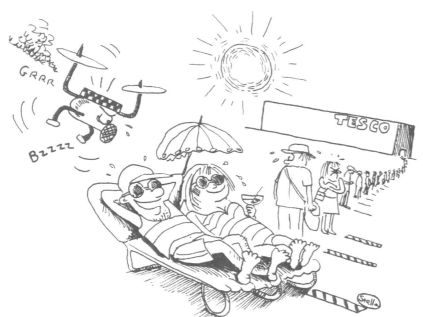

"It's OK, Officer, we decided to combine our sunbathing with our queue for essential items"!

Police CANCEL

COUTRYSIDE WALKS!

Despite the Government saying that daily exercise was allowed, Derbyshire Police used DRONES to spy on people walking alone or couples with dogs in the Peak District, as the UK entered lockdown in one of the sunniest Springs on record.

The police called walking in the countryide "not essential" activity.

17

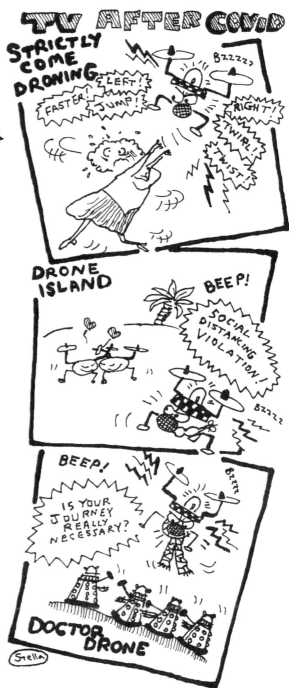

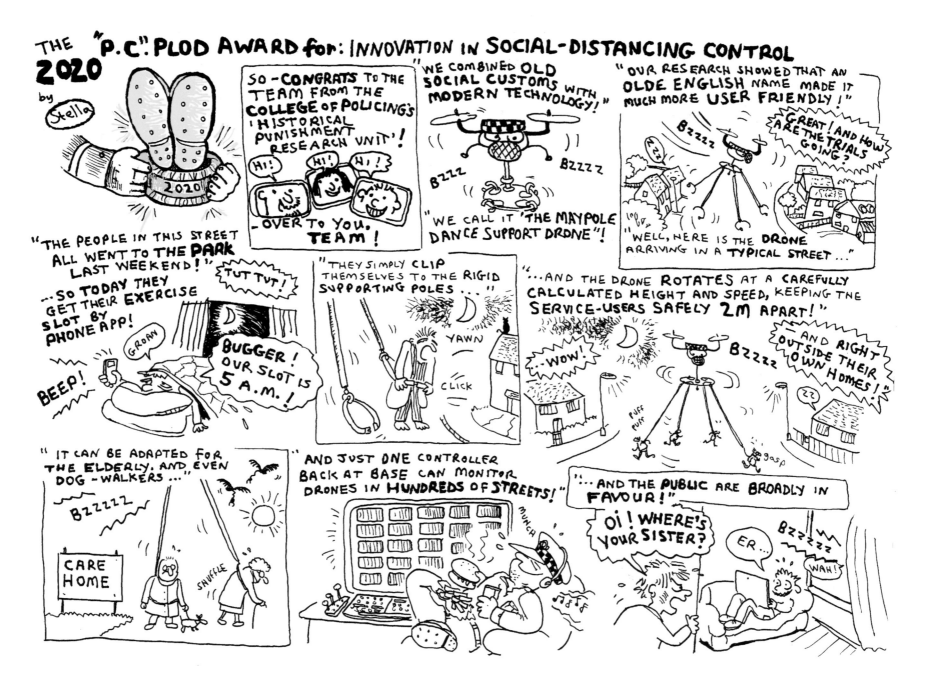

31st March

I very rarely do caricatures of World Leaders, there are so many other cartoonists better than I am at it, so I leave it to them!

Here's one I did of Boris Johnson, back when he campaigned for the Tory Leadership, then won the 2019 General Election. Everyone was asking " So where's the Magic Money Tree"?

Here he is bouncing round the Home Counties. I am showing my age by making the Magic Money Tree a Pogo -stick!

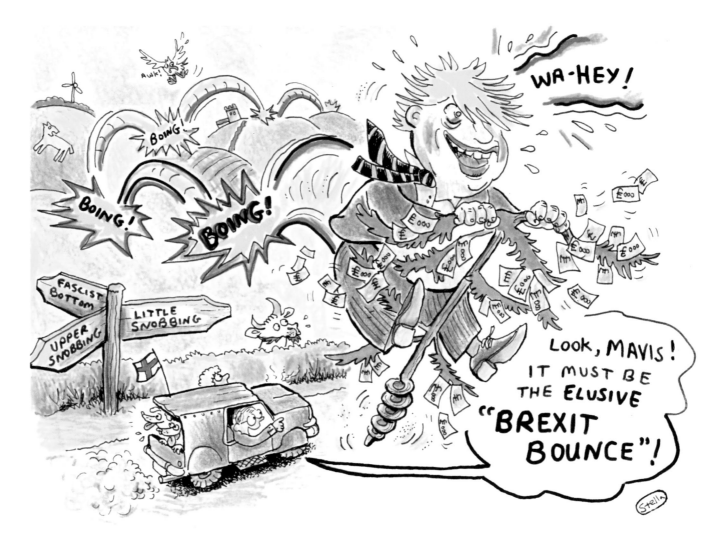

We discovered where the Magic Money Tree lived – in the person of our new Chancellor of the Exchequer, Rishi Sunak. He announced a 'furlough' scheme which would pay 80% of the wages of millions of Brits during the Covid-19 lockdown, an unprecedented government intervention.

19

The Government's ill-fated contact tracer phone App launched, in a trial on the Isle of Wight.

Alas, it only worked on the most up to date Smartphones!

I envisaged an App that could be adapted for all future national crises...

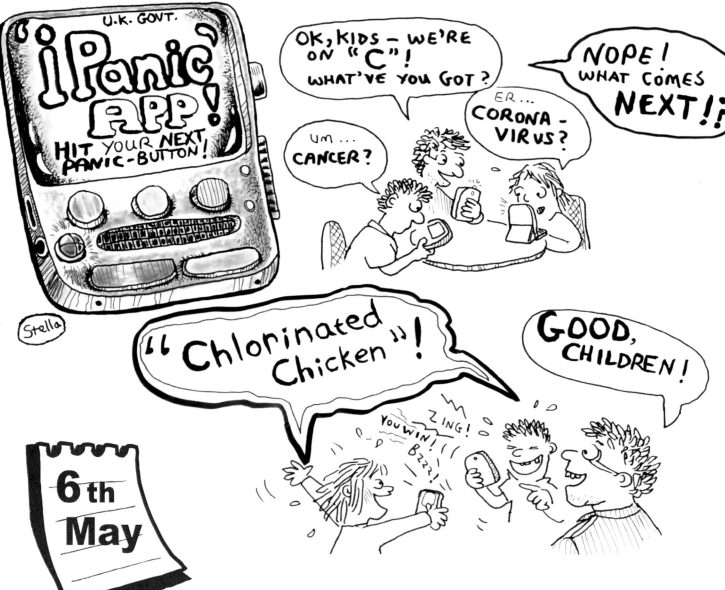

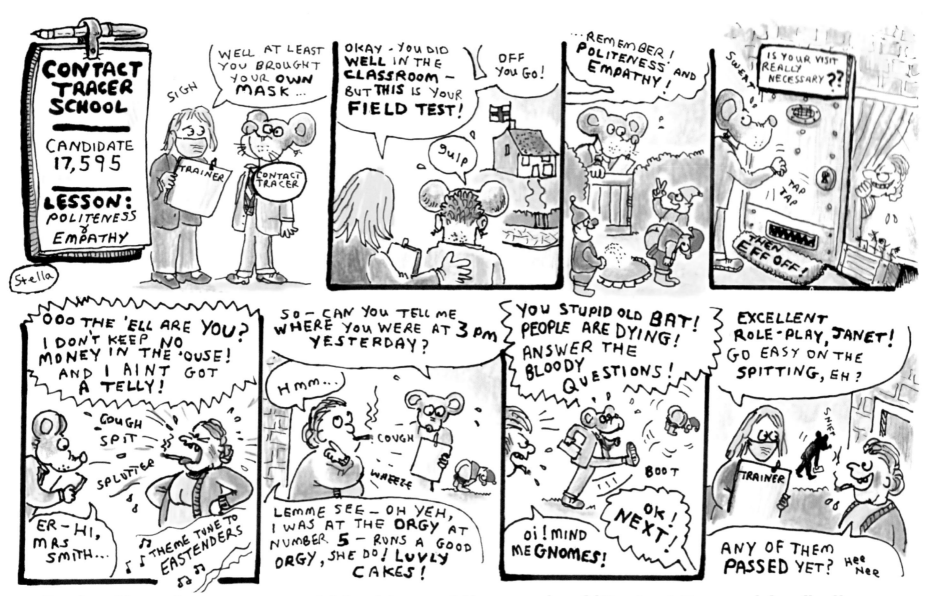

During May, the government hired tens of thousands of 'Contact Tracers' for finding people who had come in contact with Covid-19. As an ex-civil servant, I wondered how the role-play in their training would work out....

RED SNOWFLAKE ALERT!

The next 11 pages are GC! You can SKIP this section if you are easily offended!

Equality Now
A just world for women and girls.

Sex Trafficking Fact Sheet

"WOMEN, 2020"

Trafficking women and children for sexual exploitation is the fastest growing criminal enterprise in the world.[1] This, despite the fact international law and the laws of 158 countries criminalize most forms of trafficking.[2]

- Sex trafficking is a lucrative industry making an estimated $99 billion a year.[3]
- At least **20.9 million adults and children are bought and sold** worldwide into commercial sexual servitude, forced labor and bonded labor.[4]
- About **2 million children are exploited every year** in the global commercial sex trade.[5]
- 54% of trafficking victims are trafficked for sexual exploitation.[6]
- **Women and girls make up 96% of victims** of trafficking for sexual exploitation.[7]

ALJAZEERA
News · AJ Impact · AJ Go · Documentaries · Shows

Five years on, 112 still missing

At least 276 girls were taken from a government secondary school in Chibok town by Boko Haram in 2014.

by **Fidelis Mbah**

BUSINESS INSIDER

Chinese authorities are forcibly sterilizing Uighur Muslim women and performing abortions on them, an Associated Press investigation found.

A globally oppressed Class

Female genital mutilation (FGM)

World Health Organization

Prevalence of FGM

It is estimated that more than 200 million girls and women alive today have undergone female genital mutilation in the countries where the practice is concentrated. Furthermore, there are an estimated 3 million girls at risk of undergoing female genital mutilation every year. The majority of girls are cut before they turn 15 years old

The attacks on women such as Fawzia Koofi and Saba Sahar are terrorist acts to scare women not to take part in politics or social activities. The Taliban are afraid of the power and capacity of women in Afghanistan," said Sima Samar, 63, and a former Afghan minister of women's affairs. She is now a rights activist.

27 AUGUST-TIMES

Local News

Abused women reporting more violence, more risk as pandemic wears on

Women seeking help from abusive partners are reporting greater levels of violence and risk as the pandemic wears on, London's anti-violence agencies

by Richmond
2020 · Last Updated 3 days ago · 3 minute read

The London Free Press

Bangkok Post
Fury at Singapore's weak penalties

SINGAPORE: Sexual harassment and assaults against women are not being taken seriously enough in Singapore, activists warn, after students at elite universities were given punishments criticised as too lenient for their crimes.

In the most recent incident, a 23-year-old spent just 12 days behind bars after he tried to strangle his ex-girlfriend during a vicious assault.

Random clippings April-August 2020

23

Doctors soon found that the VIRUS did not adhere to the new Gender Ideology - it had ABSOLUTLY NO TROUBLE recognising men and women!

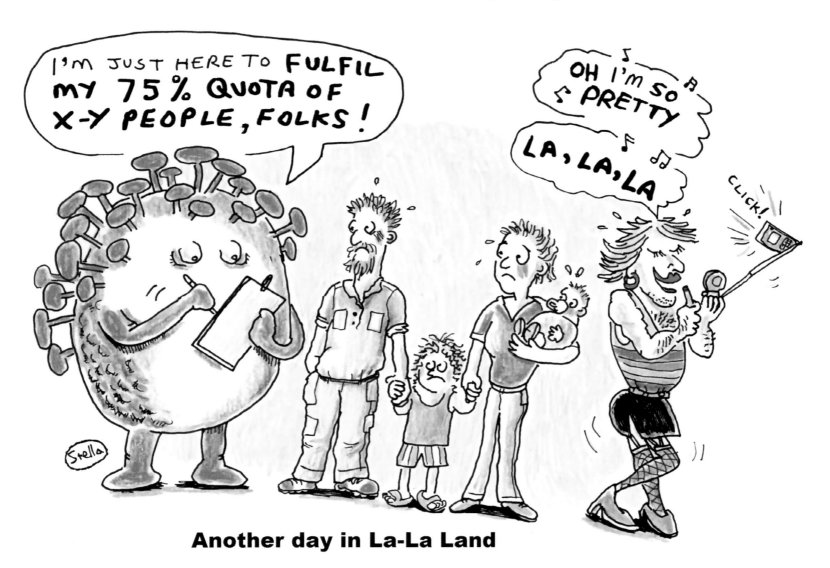

Another day in La-La Land

24

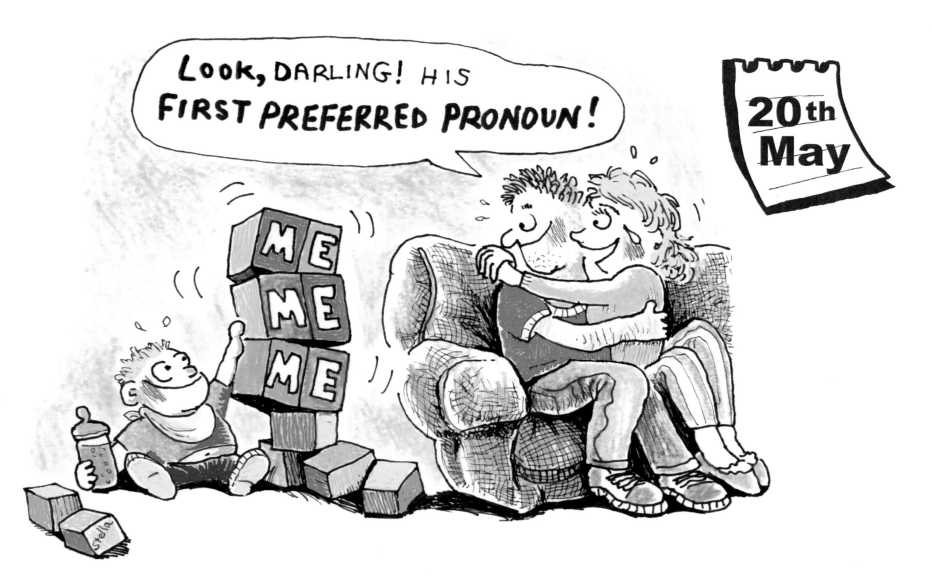

An important personal date for me: this cartoon was used to illustrate my first podcast, with feminist icon Meghan Murphy, on feministcurrent.com
The podcast is called "Why Free Speech and Satire should Matter to Feminists".

25

Our JUNE of JKR !

For many women all over the world, June of 2020 will be when they hit "Peak Trans" - the point at which you realise you have been gas-lit on the whole issue of sex and gender.

At the beginning of "Pride month" **J K Rowling** supported women online who criticised the new gender-normality.
She caused a twitter storm when she tweeted that the term "People who menstruate", (used in a third world charity advert), had confused her. "I'm sure there used to be a word for those people", she wrote "Someone help me out, Wumben? Wimpund? Woomud?"
She became the target of unrelenting death and rape threats from then on, but refused to back down, standing up for women less privileged than her, who have no voice in the "War on Women", as some commentators have called it.

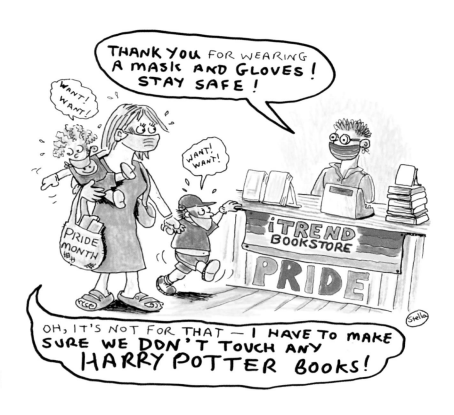

JKR – UNCANCELLABLE!

I did this cartoon for **Nottingham ReSisters,** for their birthday card for J K Rowling. Women and children from across the world sent thousands of cards to the author to show their love and support.

My cartoon features the three witches from the pen of Britain's unsung hero of feminism – the late, great TERRY PRATCHETT. A common theme throughout his 'DiscWorld' series is the second class status of women, and how they fight back against it – and usually win! Left to right; Grannny Weatherwax, Magret of Lancre, Nanny Ogg!

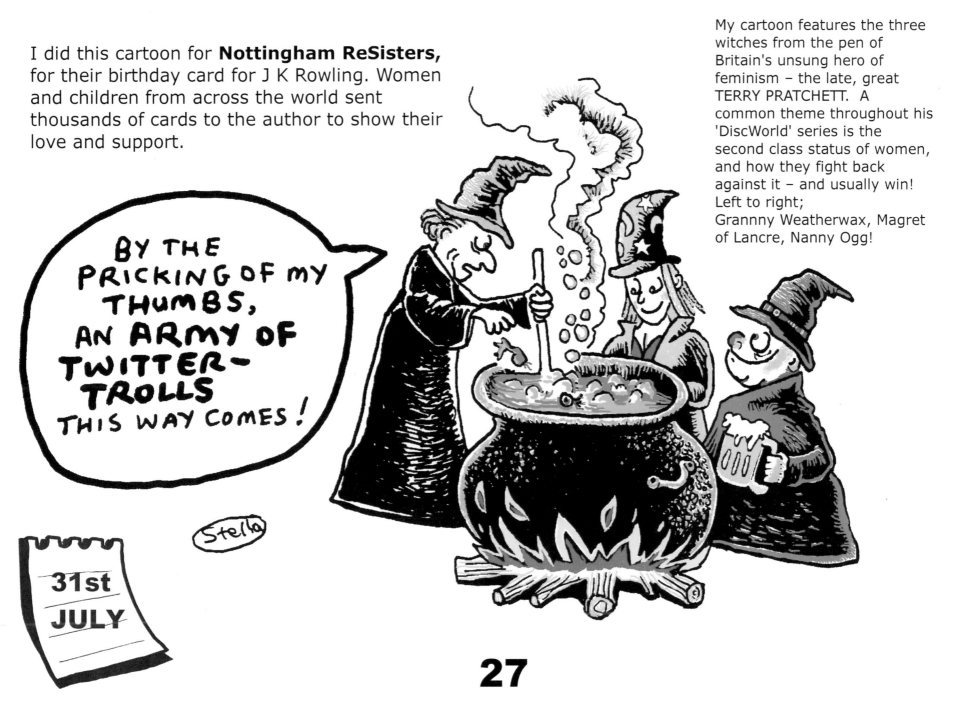

27

TALES FROM The BIG PINK BOOK!

June-July, My **GC** Summer!

I wanted to do a comic strip about the nonsense ideology surrounding sex/gender, and what better way than to try and see it through children's eyes. Children question and argue everything, they believe in fantasy. It's all part of growing their creative brains.

Tales from the Big Pink Book is at:
www.spanglefish.com/thebigpinkbook

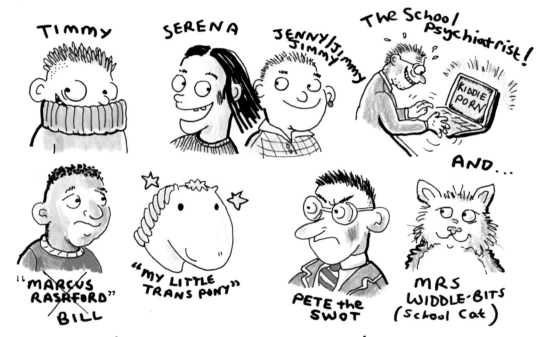

These cheeky children go to a special school for kids with Gender-Dysphoria -but they are too young to know what it means! So they spend their time running rings round their terribly Woke teachers!

28

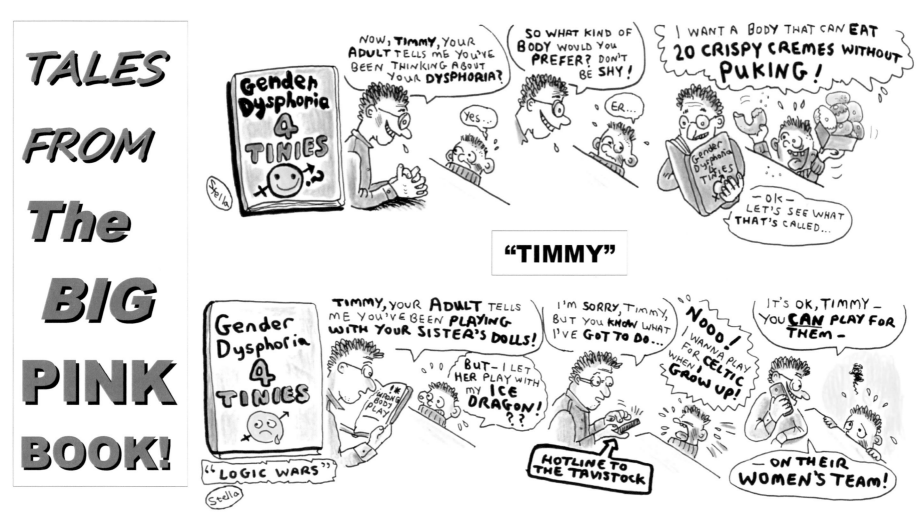

In my SPECIAL SCHOOL for kids with dysphorias, they have a weekly session with a SHRINK! Lucky kids, eh?

NOTE: The **Tavistock Clinic court case** was delayed this year because of Covid -19 causing backlogs in the court system. It is due in October. I do not know whether school shrinks or welfare officers actually had a 'hotline to the Tavistock' phone on their desks, but as it is the UK's only Gender Identity Dysphoria clinic for under -18s, I would not be surprised!

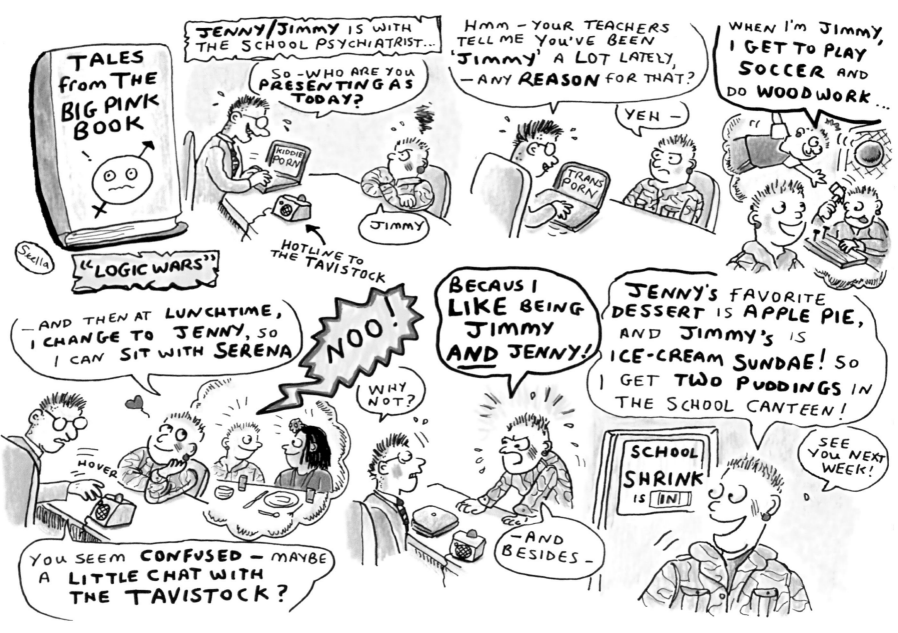

One for the Resisters!

TALES FROM The BIG PINK BOOK!

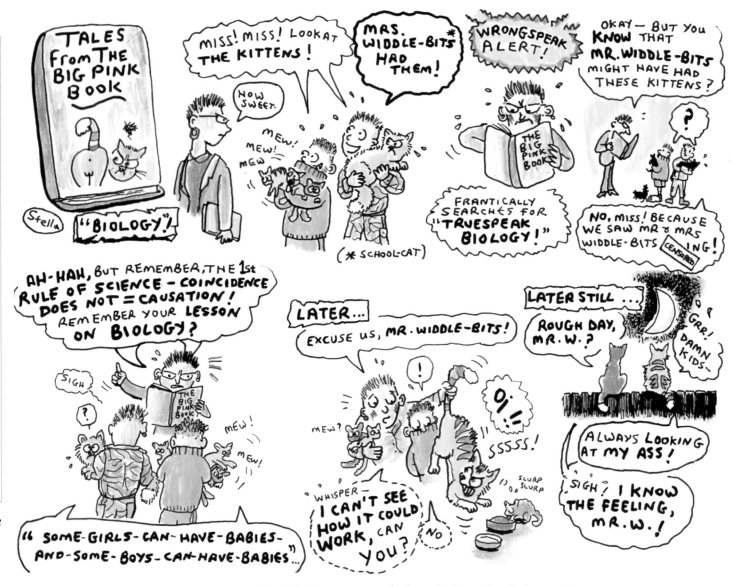

These are some of my favourites from TBPBk –

you can see more "Tales" at:

www.spanglefish.com/thebigpinkbook

31

Self-Identification does not bother anyone, until what you decide to identify as impinges on someone else's existing, hard fought-for rights.

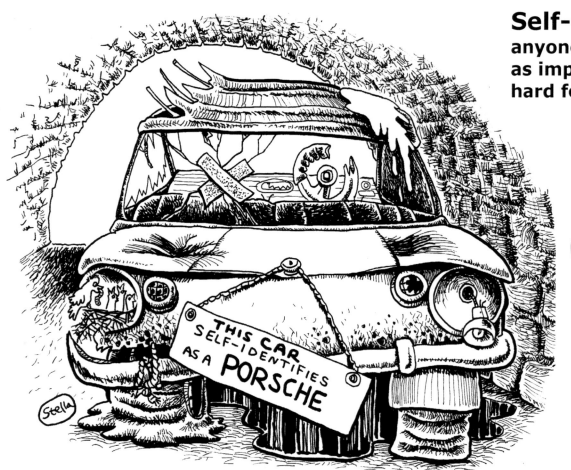

RED SNOWFLAKE RATING:

❄ ❄

Porsche owners,
All women everywhere

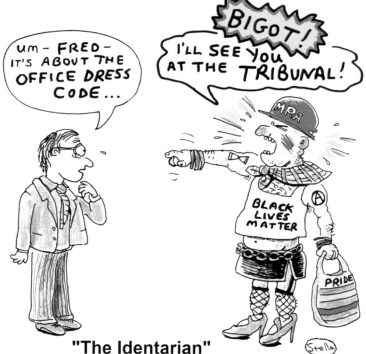

"The Identarian"

32

PRONOUNS...

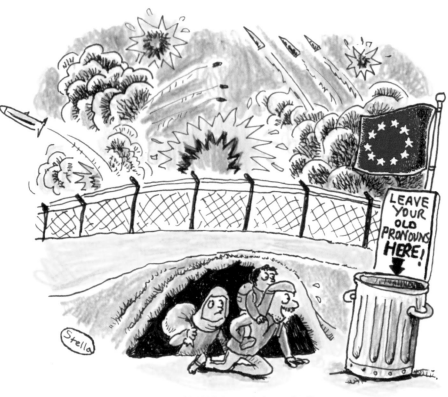

"Praise Allah! We've made it to safety"!

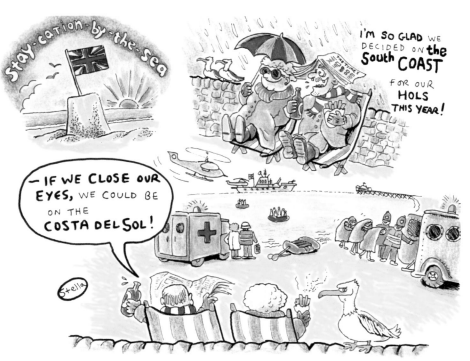

...and why MOST of the WORLD COULDN'T CARE LESS

33

RED SNOWFLAKE ALERT!

PHEW! YOU're SAFE!

34

"ROCKET BOY"
CANCELLED HIMSELF in April-May!

Crazy dictator of the prison-country North Korea, Kim Jong Un vanished for a month; the World's press speculated that he had Covid-19 or some worse illness.

Then in July, his SISTER, who he seemed to be grooming as his successor, also disappeared. Was she ill - or cancelled permanently?

Throughout 2020, Rocket Boy continued to threaten his neighbours within rocket range, Japan and South Korea.

I have done very few caricatures of world leaders – this one could not be published by the Morning Star, because of their support for Rocket Boy's protector, Communist China.

We will never know how many people in his secretive kingdom have been CANCELLED by COVID-19.

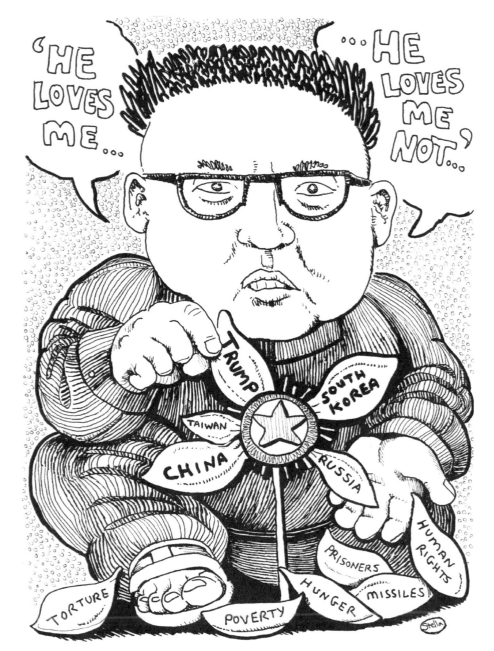

35

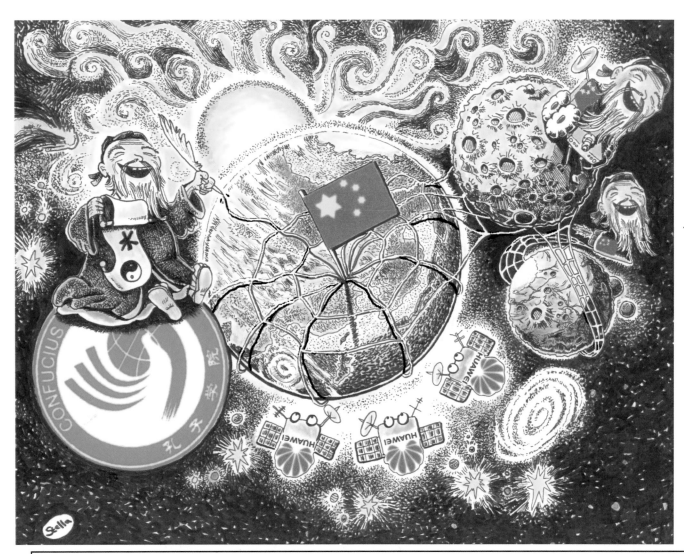

This cartoon on Chinese world domination, featuring the Confucius Institutes and HUAWEI, appeared on *uncommongroundmedia.com*

❄ **RED SNOWFLAKE RATING:**

Gulag-entry level

CHINA THREATENS UK with 'consequences' for offering citizenship to up to 3 Million Hong Kong refugees who might want to flee from their crackdown on freedom and movement. China has broken the 1984 Sino-British Joint Declaration.

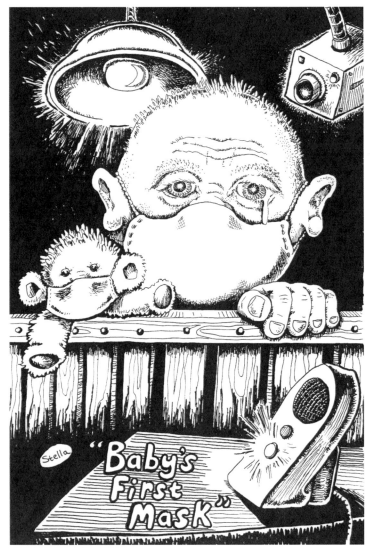

OUR FACES IN UK SHOPS - CANCELLED!

Someone said to me this cartoon is creepy because the baby has "an old man's face".

But I think you can see the future adult in all babies faces.

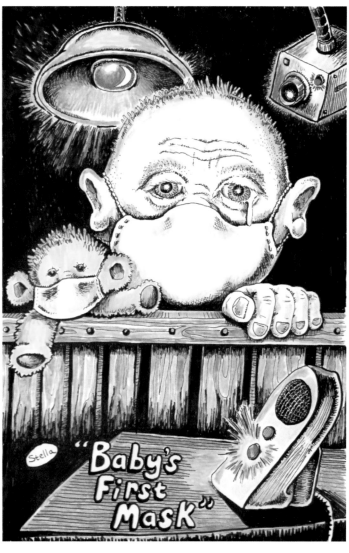

"Baby's First Mask" has appeared on uncancelled.co.uk. Many parents make their children wear masks, even though kids are exempt. This cartoon emphasises the lack of real human contact western children have - despite, or because of, being so cossetted and monitored.

37

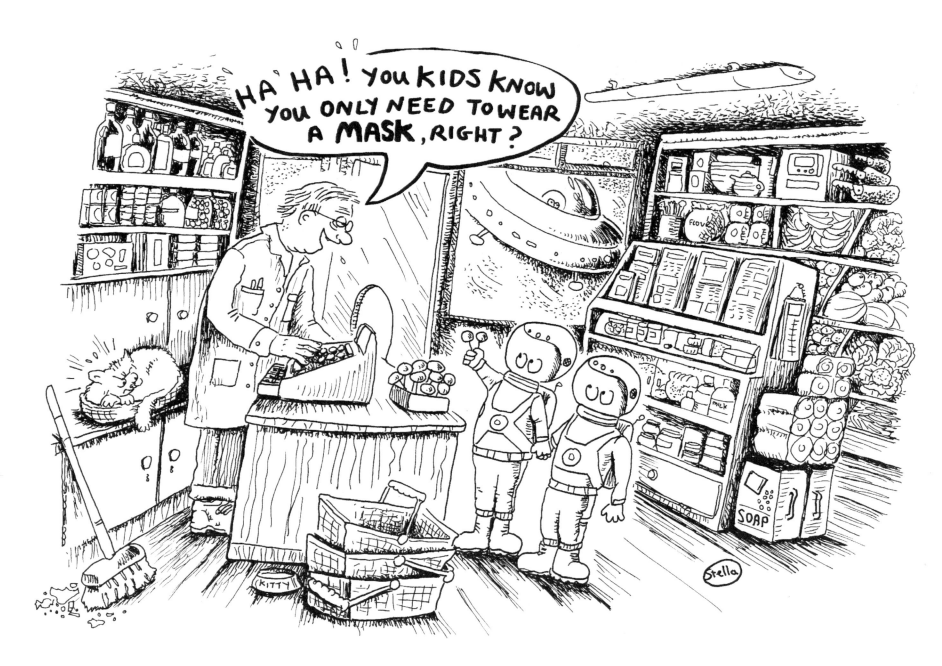

38

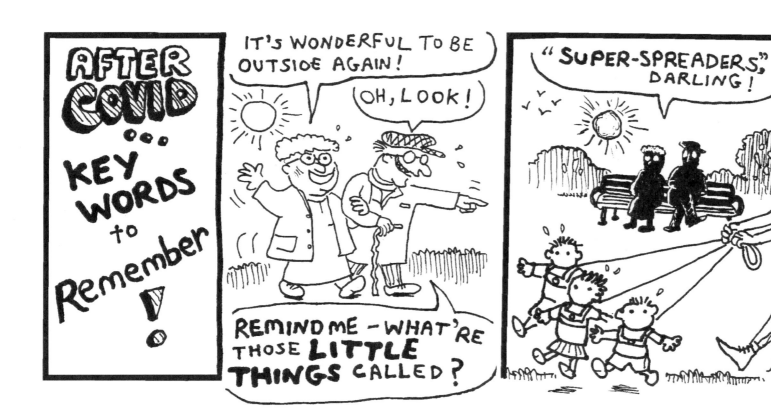

MILLIONS STILL CANCELLED!

People over 70, and those with severe health conditions, had to 'shield' themselves from the start of the Lockdown, which meant becoming prisoners in their own homes for many months.

The long term effect on mental health of forced isolation has previously only been studied in prison populations.

Sociologists are having a good pandemic!

After feeling the Cold Hand of Mortality during his own personal Covid Crisis, Boris decided a new anti-obesity war would help Brits recover from the lockdown!

So one of the first big announcements was FREE BICYCLES ON THE NHS!

27th July

RED SNOWFLAKE RATING:
Senile Dementia Fat-Shaming

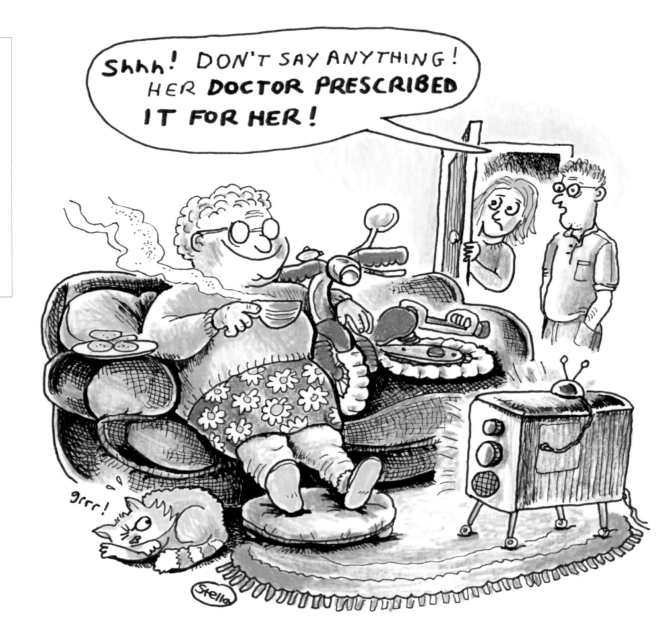

40

As soon as the government's new anti-obesity drive was announced, Local Councils complained about organised fitness sessions in parks, because:

They damage the trees!

They use park furniture inappropriately: that bench with the plaque on it for someone's deceased Spouse is for sitting on, not doing press-ups!

They crowd other park users on paths and steps!

They make too much noise!

They take up space and air!

My cartoon suggests other public spaces where councils could allow organised fitness sessions …

("A Typical Day on the M5")

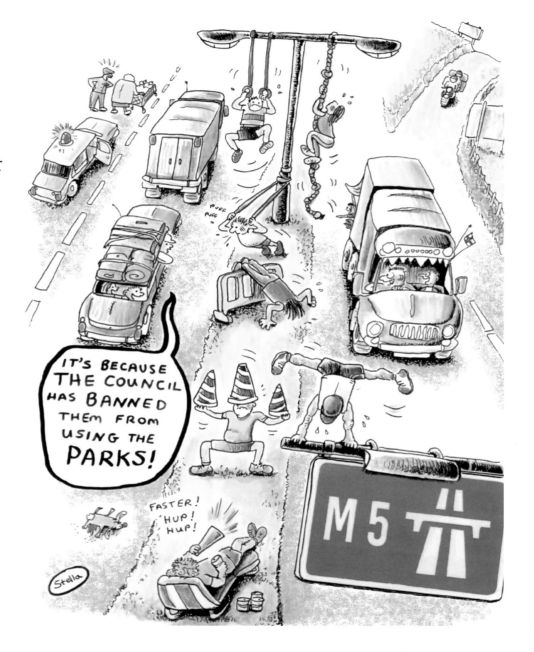

RED SNOWFLAKE RATING:
Fat-Shaming, Distracting drivers, Animal cruelty, Senile Dementia

BLM PROTESTS swept the world, following the killings of black men in police custody in America.

Copy cat protests in Britain were soon hijacked by the usual rent-a-mobs of :

greens,

anarchists,

communists, and

transactivists.

The UK only has a limited pool of activists available to go on marches.

The police, who BLM call to be defunded, do heroic work in finding and freeing them, but ...

Meanwhile, in every city, REAL LIVE SLAVES continue to be trafficked and exploited, in massage parlours, nail bars, car washes, on farms and in cannabis factories, and through brides for sale.

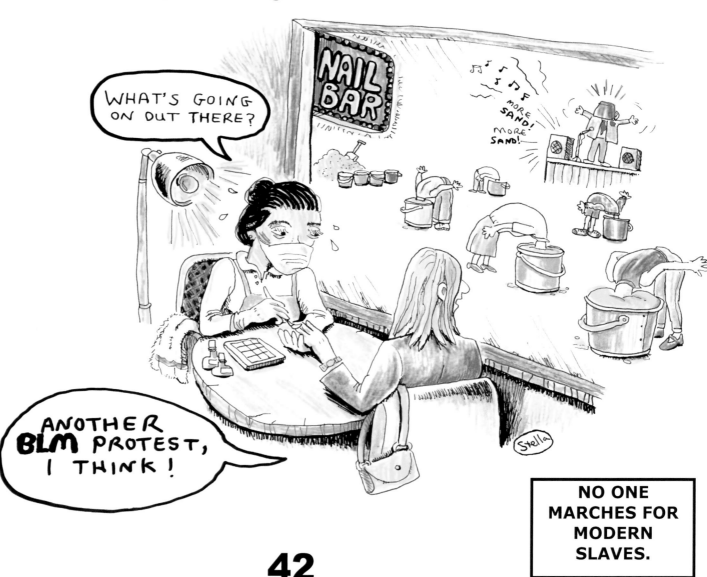

WHAT'S GOING ON OUT THERE?

NAIL BAR

MORE SAND! MORE SAND!

ANOTHER **BLM** PROTEST, I THINK!

Stella

NO ONE MARCHES FOR MODERN SLAVES.

42

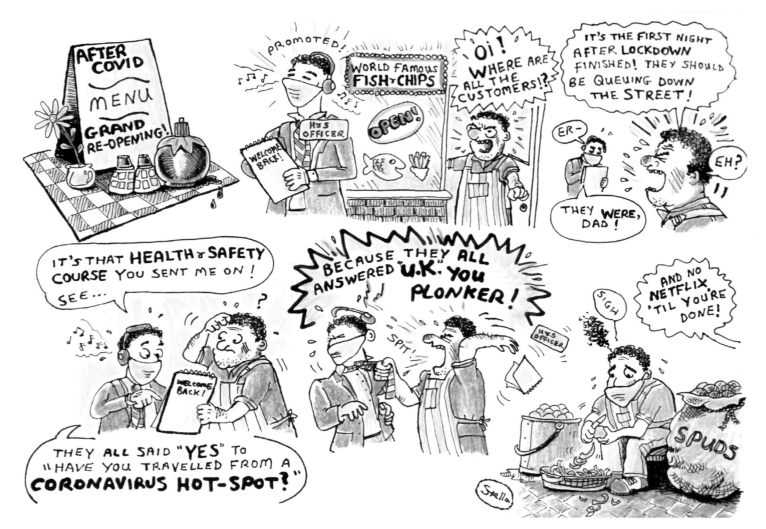

"The Grand Re-Opening"

With another shake of the "Magic Money Tree", Chancellor Rishi Sunak announced the "Eat Out to Help Out" scheme, subsidising meals out. It was mostly cheapo resteraunt chains who took advantage of the scheme, posh places either stayed closed until it finished, or had enough loyal customers anyway.

43

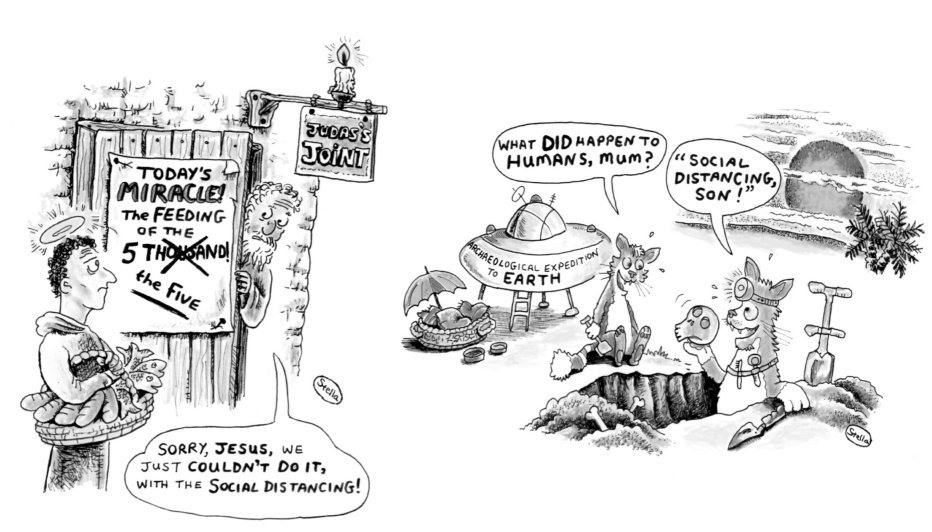

44

The Autumn of our DISCONTENT?

9 th August

Happy Birthday
POSY SIMMONDS! My inspiration for almost 50 years!
Guardian cartoonist from 1972-2007 and still drawing!

45

"Standing for Women" Speakers' Corner event disrupted by BLM protesters

AUGUST BANK HOLIDAY and 1ˢᵗ WEEK of SEPTEMBER –

WHAT A WEEK FOR Free Speech and NON-CANCELLATIONS !

TheNewArab

JORDAN!

The New Arab Staff
Jordan releases cartoonist Emad Hajjaj after days of arrest for 'offending' the UAE

Hajjaj was detained

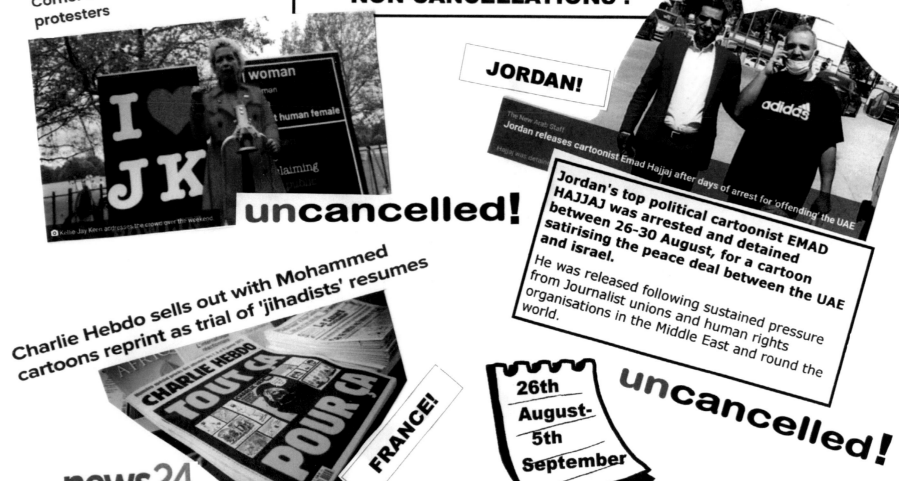

Kellie-Jay Keen addresses the crowd over the weekend

uncancelled!

Jordan's top political cartoonist EMAD HAJJAJ was arrested and detained between 26–30 August, for a cartoon satirising the peace deal between the UAE and israel.

He was released following sustained pressure from Journalist unions and human rights organisations in the Middle East and round the world.

Charlie Hebdo sells out with Mohammed cartoons reprint as trial of 'jihadists' resumes

FRANCE!

news24
Breaking News. First

26th August- 5th September

uncancelled!

46

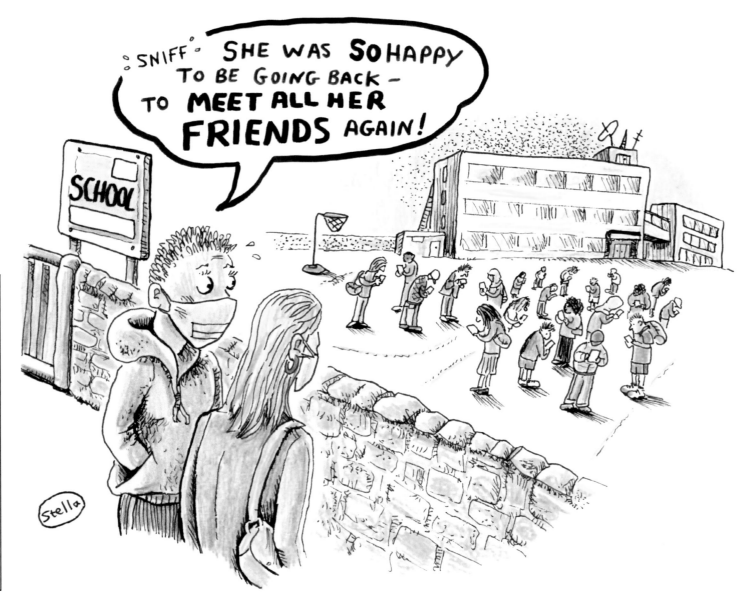

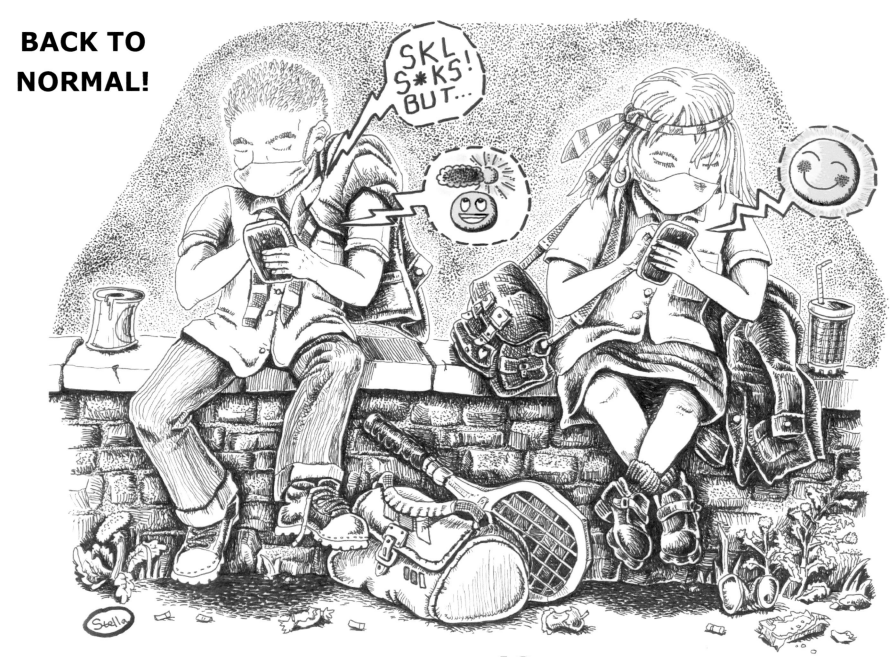

48

5th Sept.

Extinction Rebellion protesters block newspaper printing presses

Extinction Rebellion (XR) activists have delayed the distribution of several national newspapers after blocking access to three printing presses owned by Rupert Murdoch.

Protesters targeted Newsprinters presses at Broxbourne in Hertfordshire, Know in Merseyside, and near Motherwell, North Lanarkshire.

Prime Minister Boris Johnson said the action by demonstrators across the cou was "unacceptable".

Eighty people have been arrested.

But the following weekend - "Extinction Rebellion" Anarchists CANCELLED the Newspapers!

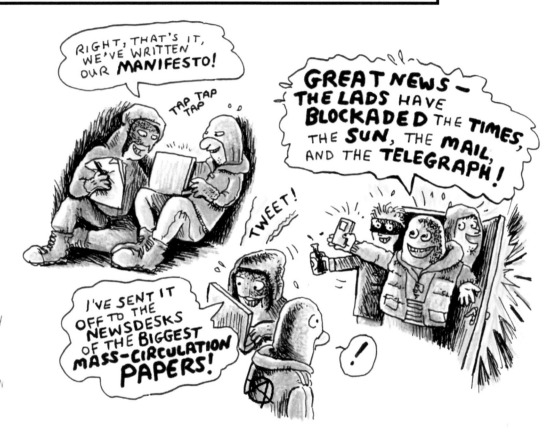

Politicians and Journalists from across the political spectrum joined in condemnation. Closing down free media is normally the first stage of a dictatorship.

Even XR's leaders distanced themselves from the actions.

49

9 th Sept.

OZ Journalists CANCELLED!

Completely unabashed by condemnation of their lack of clarity over the timing of the Covid-19 outbreak, the HUAWEI controvesy, or their treatment of the Uighars, and Hong Kong protesters, China carried on regardless throughout 2020.

RED SNOWFLAKE RATING:

Members of the CCP

9/9/20

The Times **World** 33

Reporters tell of escape from China

China

Didi Tang Beijing
Bernard Lagan Sydney

The last two Australian correspondents working from China have fled after being given diplomatic shelter during a five-day stand off with police in Beijing and Shanghai.

The Australian Broadcasting Corporation's Beijing correspondent. Bill Birtles, and the *Australian Financial Review*'s Shanghai-based reporter. Michael Smith. arrived in Sydney yesterday morning after the Australian government negotiated with the authorities for them to return home.

It was only after their plane had landed that it was revealed that both of them had been sheltered for five days inside Australia's diplomatic missions in China after fears they were about to be seized and detained indefinitely.

Both journalists were told they were people of interest in a police investigation into Cheng Lei, the Australian citizen who was the face of China's state-run English news service until she was suddenly detained last month.

"Another Tasty Morsel"

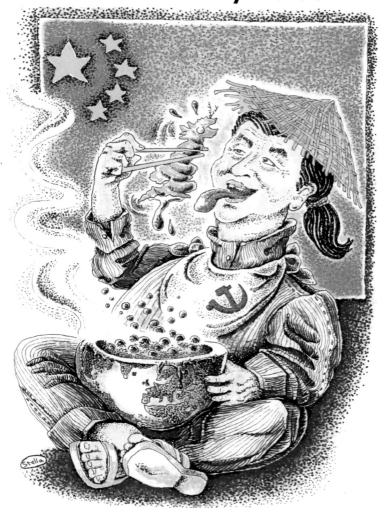

My "China" cartoon, originally for the 2015 State Visit to the UK of President Xi Jinping. The prawn is the UK, being fished out of a bowl of the Earth. The *Morning Star* refused to publish this cartoon.

50

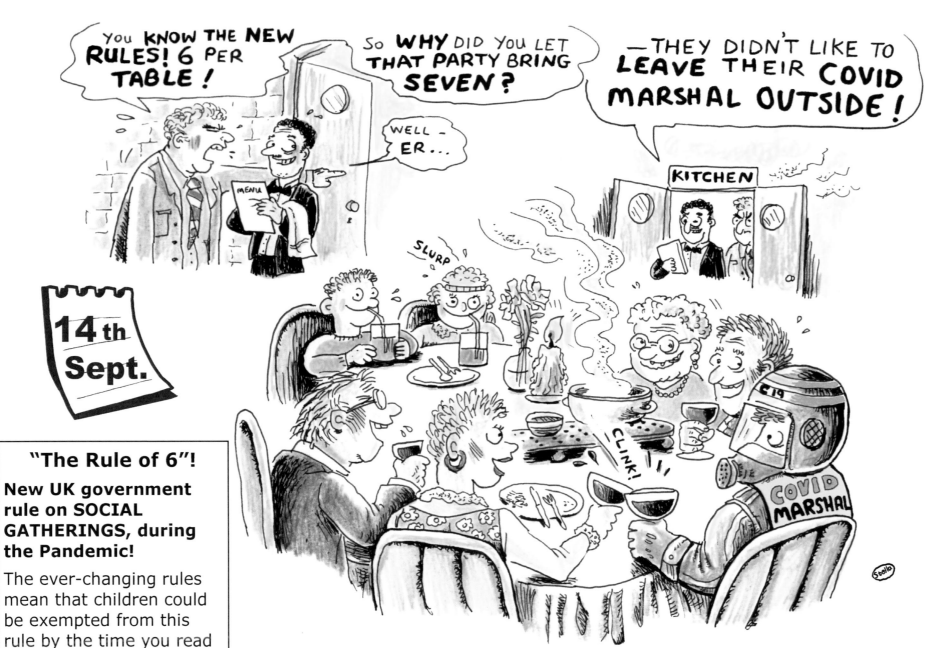

"The Rule of 6"!

New UK government rule on SOCIAL GATHERINGS, during the Pandemic!

The ever-changing rules mean that children could be exempted from this rule by the time you read this book!

51

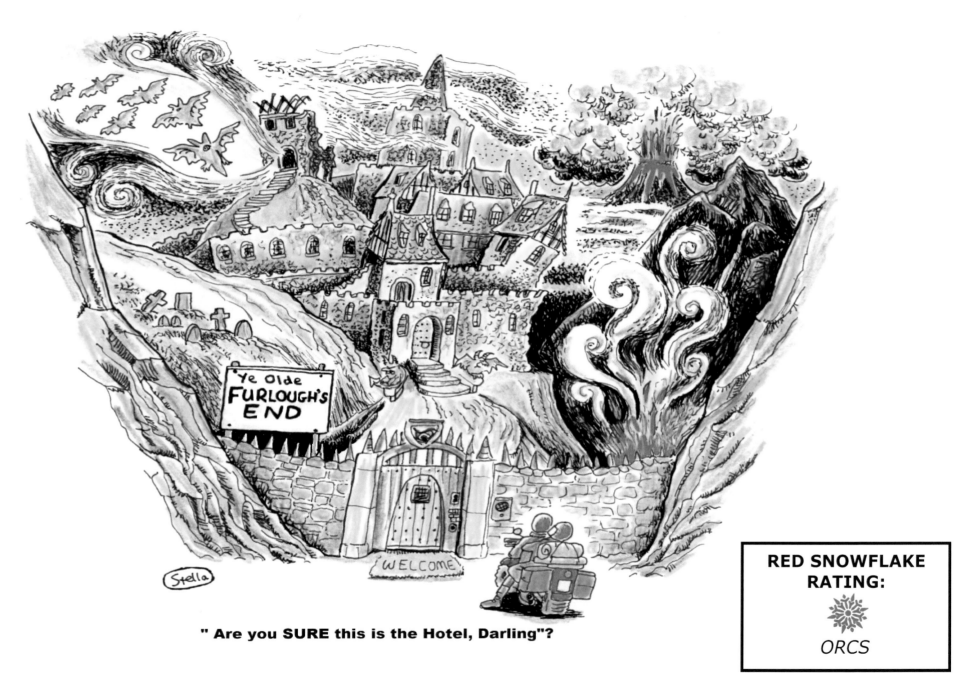

"Are you **SURE** this is the Hotel, Darling"?

RED SNOWFLAKE RATING:

ORCS

52

The next 4 pages are GC! You can SKIP this section if you are easily offended!

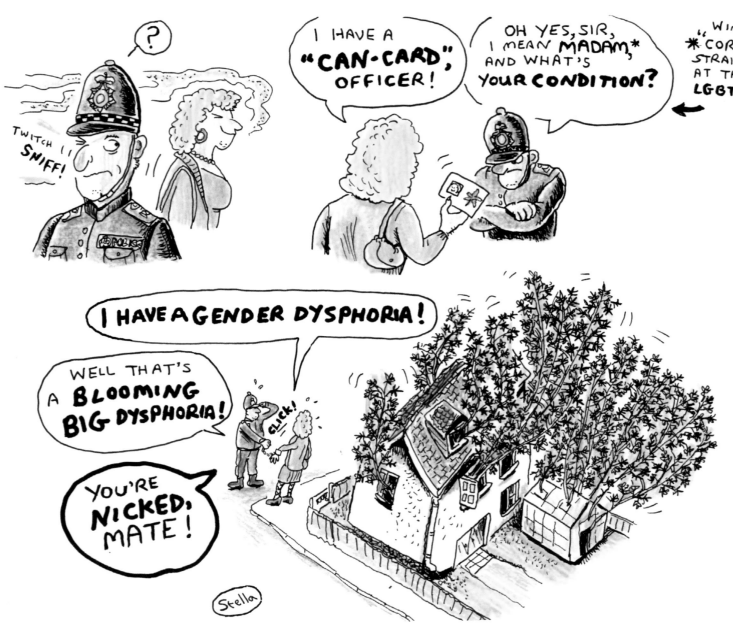

8th Sept.

Police announced that from November they will accept a **"Can-Card"**, a privately produced **ID card for cannabis users to carry, to alert police to their medical conditions.**

It does not allow criminal posession!

How will they detect forged ones, and who decides what is a medical condition?

I'm sure the British Police, ("The Best In The World") will use their customary DISCRETION!

54

With other women (and men) I went to the Standing for Women Speaker's Corner Tribute to Magdalen Berns., who died at the tragically young age of 36 a year ago today.

People who knew her, or were inspired by her, gave speeches.

You can find the film of this event on youtube.

Magdalen Berns

文A Language

≡ WIKIPEDIA

Magdalen Berns (6 May 1983 – 13 September 2019[2]) was a British YouTuber, boxer and software developer. Berns, a lesbian radical feminist, came to prominence in the late-2010s as a result of a series of YouTube vlogs focusing on lesbian politics, free speech, and gender identity.[1] Berns's views attracted controversy, leading to her being described as "transphobic"[5] and a "TERF".[6] Berns also co-founded the group For Women Scotland (Forwomen.Scot)[7], which opposes proposed changes to the Gender Recognition Act 2004.

7th Oct.

The TAVISTOCK CLINIC Judicial Review

rumbled on all year, delayed by the Lockdown and court staff being furloughed, and is finally being heard in October.

Former patients, parents, and staff members are all involved in suing the clinic, the UK's only gender identity clinic for under-18s.

This hugely important case will influence the UK and other countries' policies on providing drugs, hormones and surgical interventions for children, for years to come.

MEANWHILE, in Dr FRANKENSTEIN'S LABORATORY...

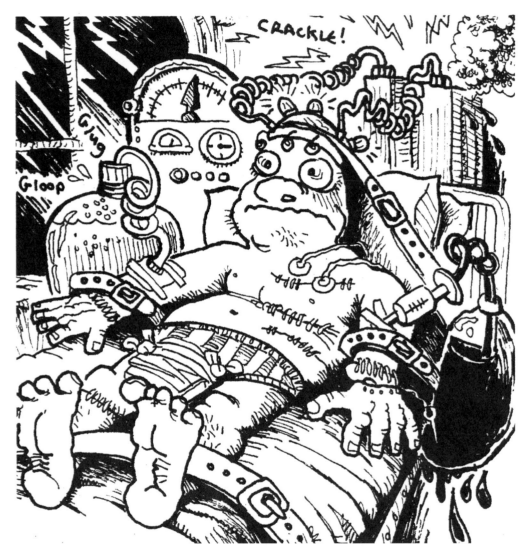

"Blimey – I only came in to get me EARS SYRINGED"!

56

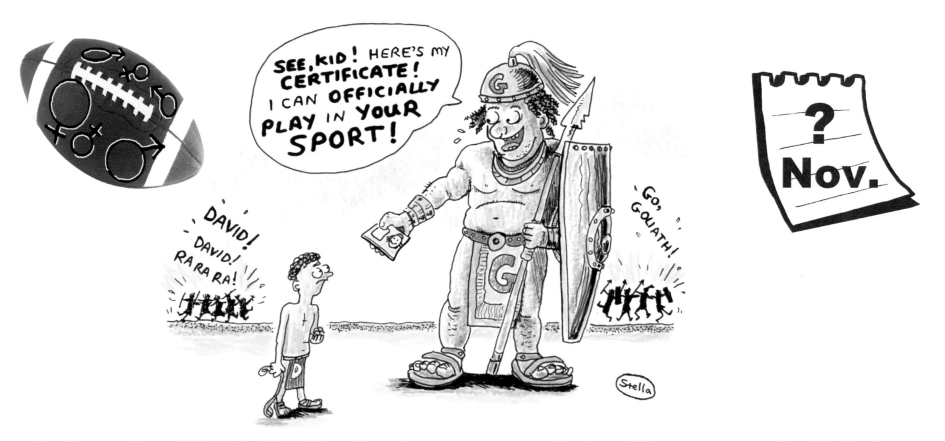

In November, WORLD RUGBY will vote on a proposal to ban "Trans-women" with their greater body weight, speed, and strength, from Women's Rugby.

They aready compete in other women's sports, (individual and college-level sports, especially in America) such as Track & Field, Swimming, even Mixed Martial Arts!

But with the postponed 2021 Olympics in sight, all Olympic Sports will HAVE to take a decision. Will "Women's Sport" exist in name only by the time you read this book?

IF THERE IS NO CONTEST, THERE IS NO "SPORT" - THE WORD BECOMES MEANINGLESS.

57

RED SNOWFLAKE ALERT!

PHEW! YOU're SAFE!

58

As Covid19 cases rose in the US, President Trump – who boasts that he's never had a Flu jab- seemed STRANGELY KEEN to try any and every alleged cure for the VIRUS…

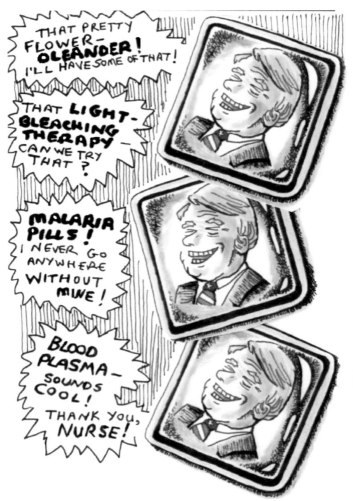

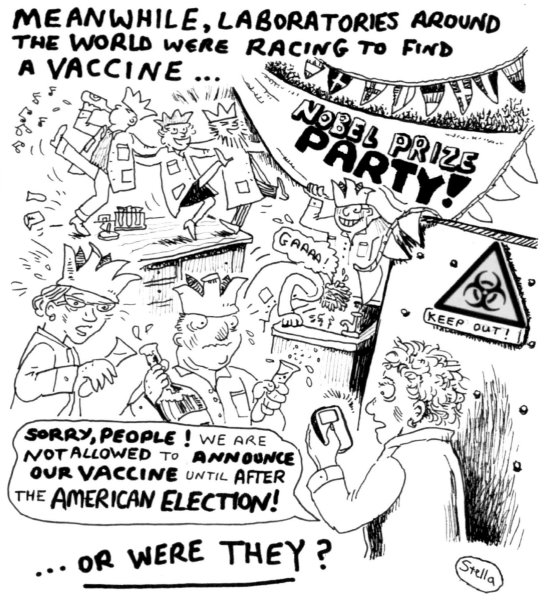

59

Another American Election –

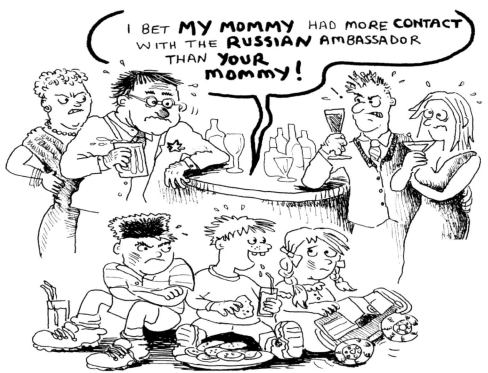

The Embassy Cocktail Party

and "The Russians are coming! Again"!

"Maureen, I'M AS SURE AS I CAN BE that the SAGA WEBSITE has not crashed because of RUSSIAN HACKERS! Let's try again!"

From mid-September, the Government's most sinister intervention yet to try and CURB the PANIC-DEMIC:

China-style neighbourhood snoops, sorry, "Covid Marshals".

These official busy-bodies were employed to prowl streets, parks, and public areas, to instruct the rest of us on safe social distancing and break up gatherings of 'too many' people.

(This number varied in the devolved nations of the UK because, by this time, the Covid -19 virus had MUTATED, and was able to recognise the borders of Scotland, Ireland, or Wales when it crossed them, and adjust its behaviour appropriately).

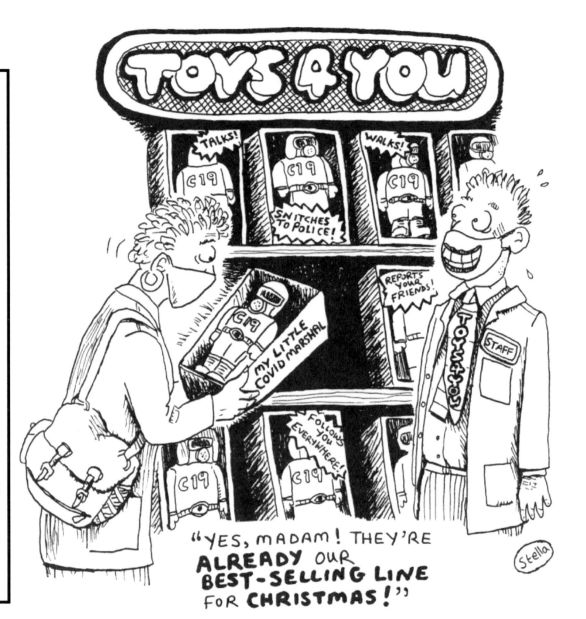

"YES, MADAM! THEY'RE ALREADY OUR BEST-SELLING LINE FOR CHRISTMAS!"

3rd Nov.

So here we are, another bizarre American Election, and it has already been the strangest year of our lives!

What has changed since the last one?

A huge loss for freedom of speech and women's rights, for sure.

But in terms of World Peace, global poverty, inequality, racism, oppression, hunger? On the face of it, "not a lot".

This is "my Trump cartoon". I've had criticism of it, that I haven't made him "nasty enough"!

Excuse me- that's not my job!

I was trying in this cartoon to depict Donald Trump as I think he SEES HIMSELF.

These cartoons first appeared in the March 2017 special edition of *fenamizah* magazine.

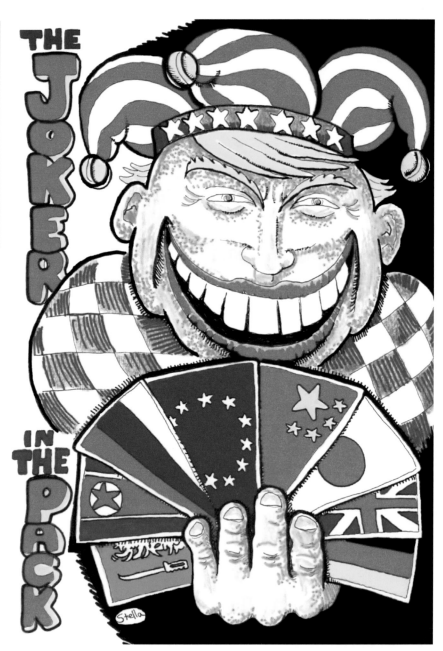

62

This cartoon is called "The Writing's on The Wall".

PENAL COLONY 22 of the "Democratic Republic of Korea" is the one we know most about, from defectors to South Korea.

Whole families, including children, have been born, grown up, lived, laboured, been tortured, and died, inside Rocket-Boy's Gulag.

His secret, backward country, allows no foreign journalists or politicians except on highly restricted propoganda visits.

Human Rights organisations can't even get reliable statistics out of North Korea.

We have no idea how the Covid-19 Pandemic has affected the country.

Because it is supported by China,the West politely closes its eyes.

What will yet another American President mean for the 'citizens' of the biggest open-air prison on Earth?

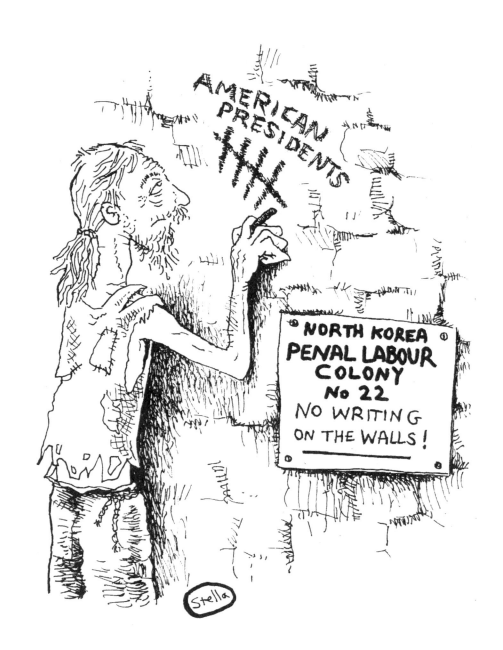

63

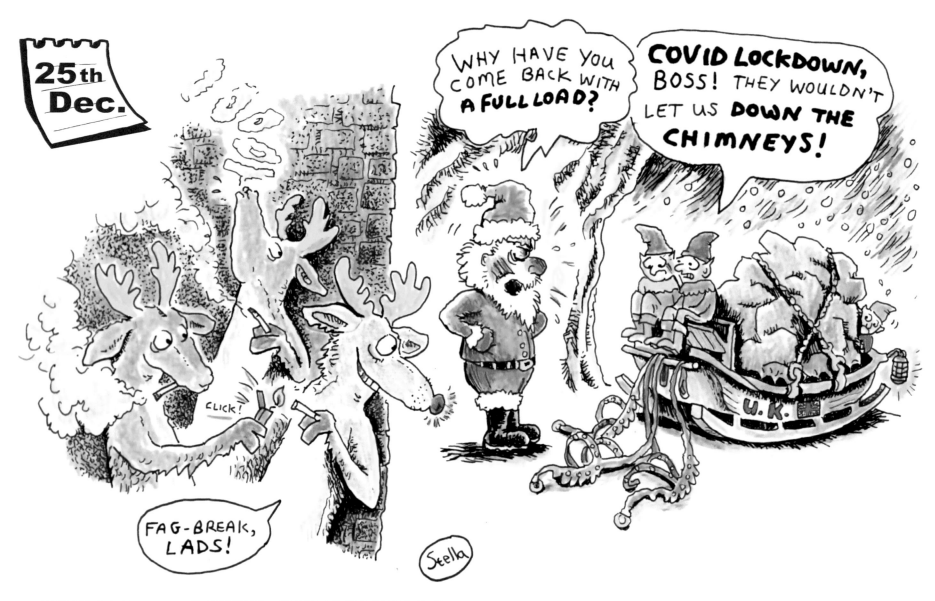

Will it be a COVID CHRISTMAS? *(Morning Star readers might remember my smoking Reindeer)!*

The PANIC-DEMIC almost made us forget, but now it's here...
Will we finally get the Brexit we wanted?

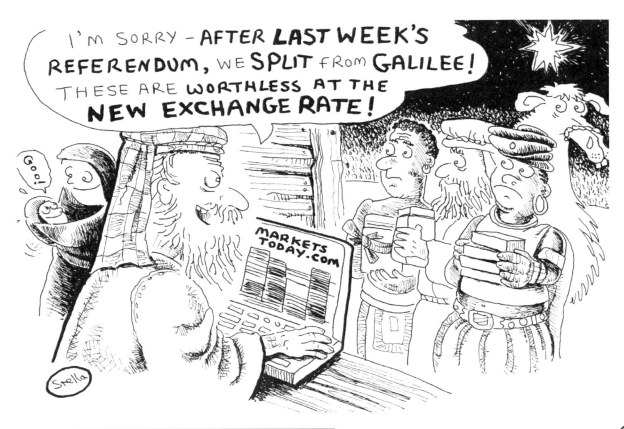

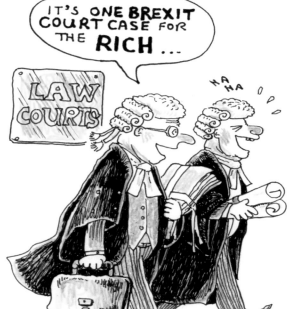

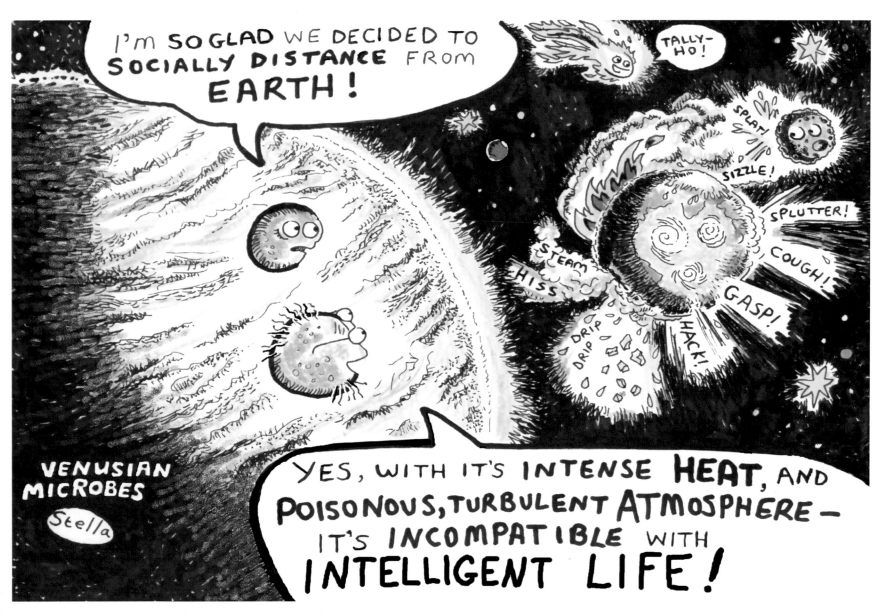

Scientists announced they have found signs of
microbial life in the hostile clouds of VENUS...

66

HUGE THANKS to all the people who have given me moral support, and written about my cancellation in "2020 - The Year We Were All Cancelled"!

You all gave me the confidence and motivation to produce this book!

BEN CHAKO and MICHAL BONCZA at the *Morning Star* - I know it wasn't your fault, guys
DAN FISHER, Uncommongroundmedia.com – Article 29 February, *The Eclipse of The Morning Star* ;
and for publishing my *Open Right Of Reply to Morning Star Readers,*17 July
PRIVATE EYE, issue 1517, in *Street of Shame, 6-19 March*
THE FREE SPEECH UNION who supported me *(freespeechunion.org, Blog, 7 June)*
JOANNA WILLIAMS, on Spiked-online.com – Article, 4 March, *How 'Woman' became a Dirty Word*
MEGHAN MURPHY, feministcurrent.com – for interviewing me for her podcast, 20 May, *Why Free Speech and Satire Should Matter to Feminists*
DEFENDFEMINISTS.NET, 14 June, news story *Cartoonist sacked from the Morning Star Newspaper*
NICK CRAVEN,THE MAIL ON SUNDAY 11 July, in *What it Feels Like To Be Cancelled*
WLRN (Women's Liberation Radio News) 12 July, published my Open *Right of Reply to Morning Star Readers*
Plus: Faircop, Kellie-Jay Keen, Jennifer Bilek, Joey Brite, and numerous other women from SPINSTER.XYZ
Uncancelled.co.uk and Uncommongroundmedia.com *who have regularly featured my cartoons*

My Editors, SOCCIONE, and my PR company, PRforBooks

And finally, thanks to my husband, who put up with three months of my constant swearing during the production of this book!

You can follow my latest cartoons on my website, at:
www.spanglefish.com/stellaillustrator *on uncancelled.co.uk and on spinster.xyz*

LAST THOUGHT for
*the strangest year of
our lives...*

As this book went to press,
the Leader of the Free
World went down with The
Lurgy.
Some of us feel that it's the
toxicity of social media
which is a large cause of
America's current sickness.

*So here's my advice for
your New Year
Resolutions:*

RESTRICT your Kids
screentime!
MAKE SURE you know
what they're looking at!
USE the I.T. safeguarding
on their devices!

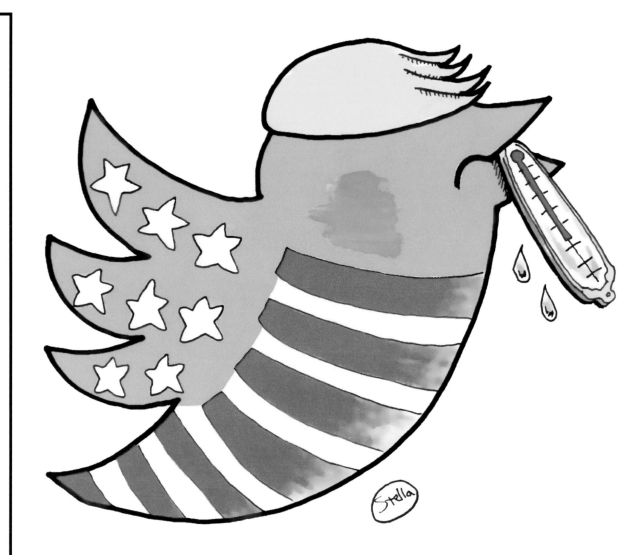

68

Anything could happen between this book going to press and New Year, 2021 – so here is a BLANK PAGE FOR YOUR OWN CARTOON!